KENTUCKY 120

a collection of photographs
by Ed Lawrence

Ed Lawrence

Published by Zedz Press, LLC
P.O. Box 10
Frankfort, KY 40602-0010
U.S.A.

Printed in China
First Edition, March 2014
Reprinted 2016

Cover photo: Hardin County, Kentucky 08.24.2004 by Ed Lawrence.
Book design: Ed Lawrence

Library of Congress Control Number: 2013955364

ISBN-10: 0991146409
ISBN-13: 978-0-9911464-0-6

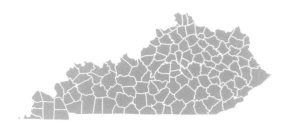

Kentuckians are proud of their 120 counties, originally formed so that people could access government within a day's traveling distance by horse, mule or foot. Most of today's Kentuckians identify their home, their growing-up years and their ancestry by county. Counties shape Kentuckians' stories and provide a strongly rooted sense of place.

The photographs selected for KENTUCKY 120 represent the most artful imagery in each of the commonwealth's counties. The photographs were made by Ed Lawrence during his journeys on Kentucky backroads — without a destination in mind. Accumulating thousands of photographs over the years, he found the easiest way to catalog them was by county. While a few pictures portray readily identifiable local landmarks, most locations would only be known by those who own the land or pass by on a regular basis. Many were shot on public lands.

Ed Lawrence uses a square format to frame the scene for his viewers as if they traveled together to each county in the state. Earth, water and sky are at the core of his work, capturing the line, color and form of landscapes shaped by nature, humanity or both. Through these photographs, Ed Lawrence conveys his love and deep connection to all of Kentucky, from the Mississippi River to the Appalachian Mountains.

Dedicated to
my Aunt Margaret
who made it possible
for me to love
Kentucky.

♥

a portrait of Kentucky

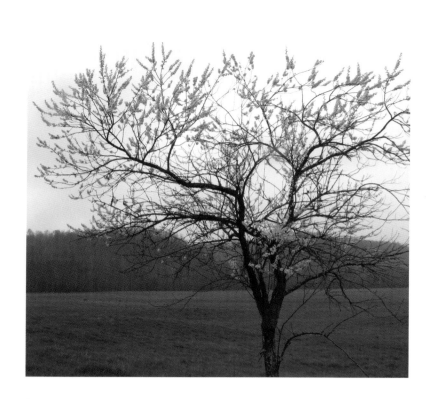

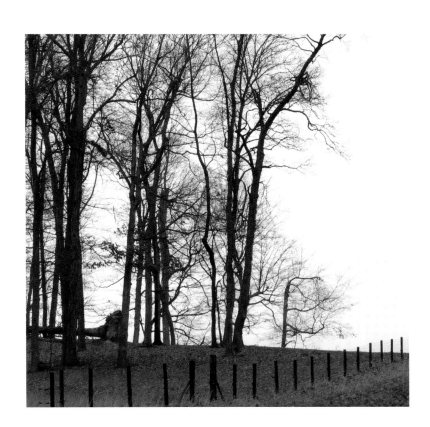

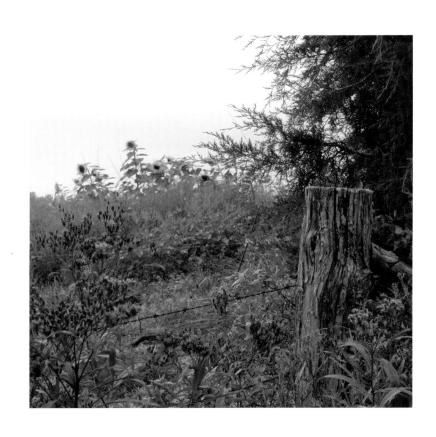

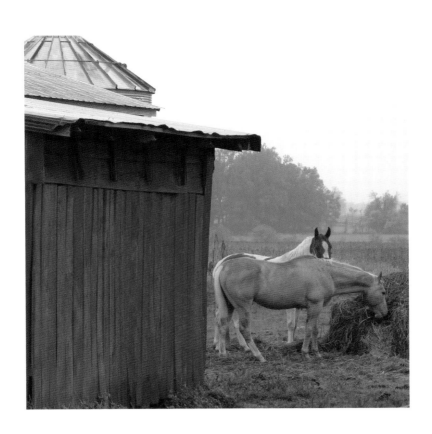

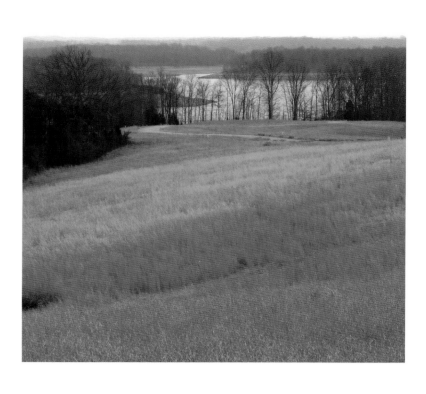

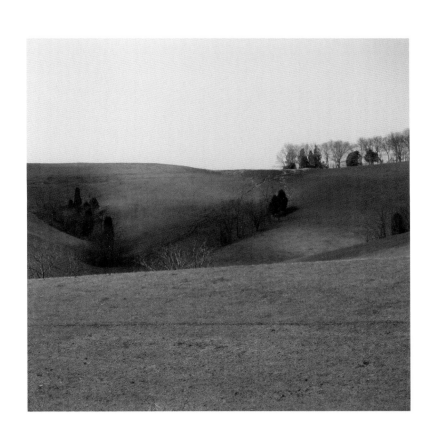

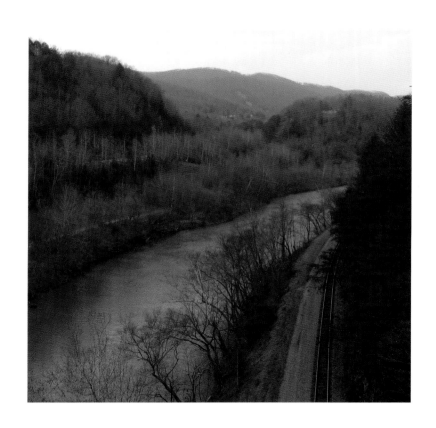

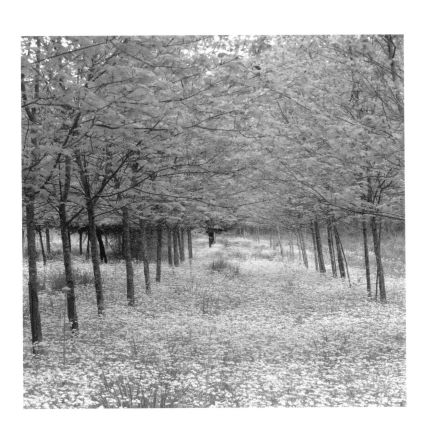

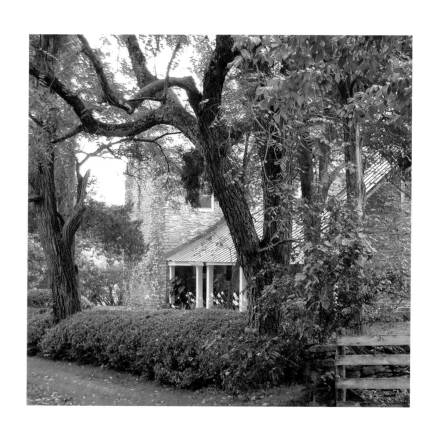

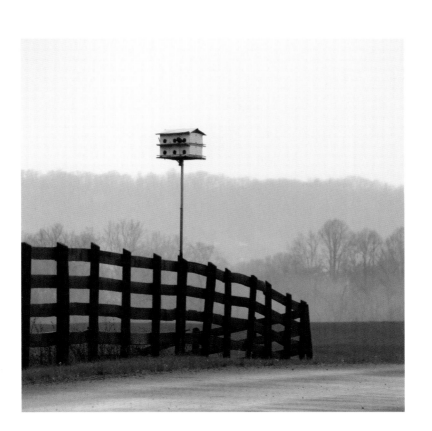

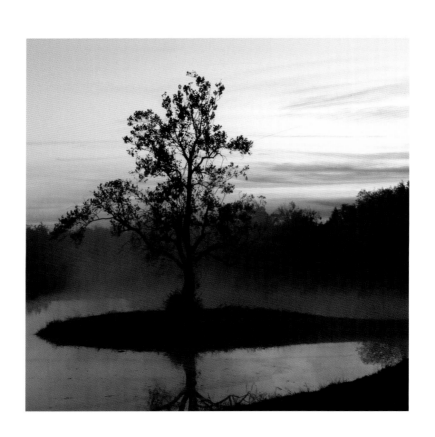

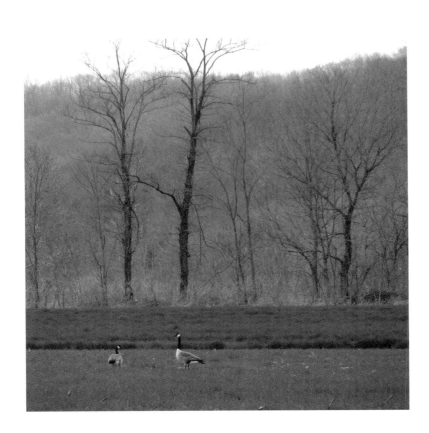

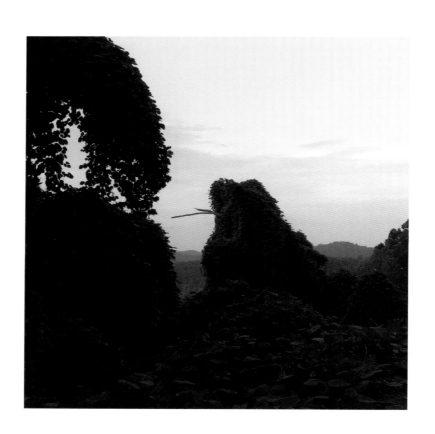

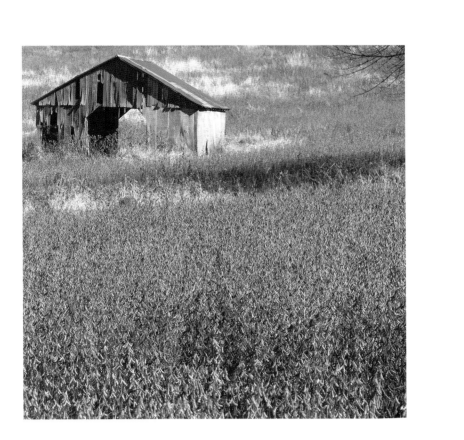

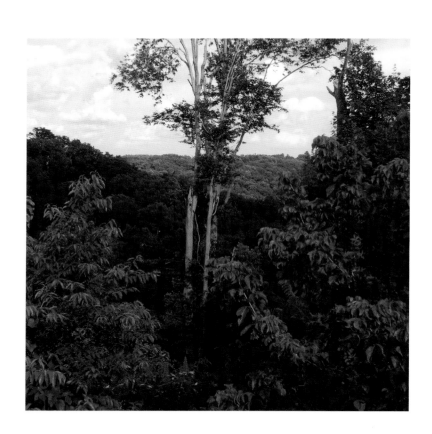

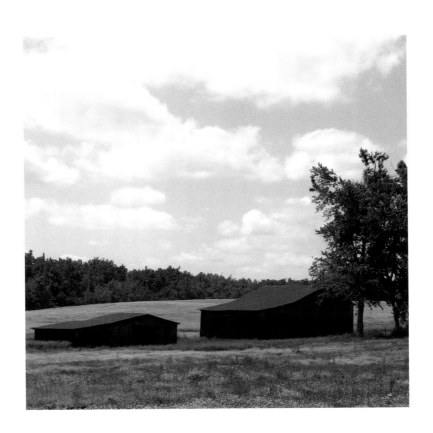

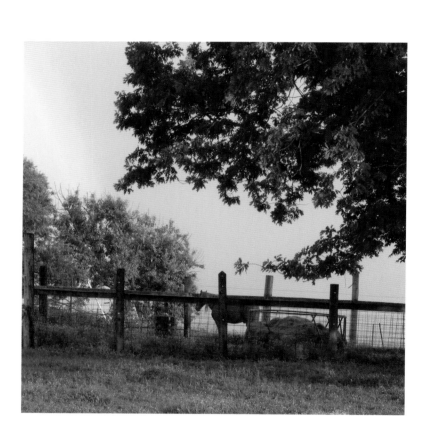

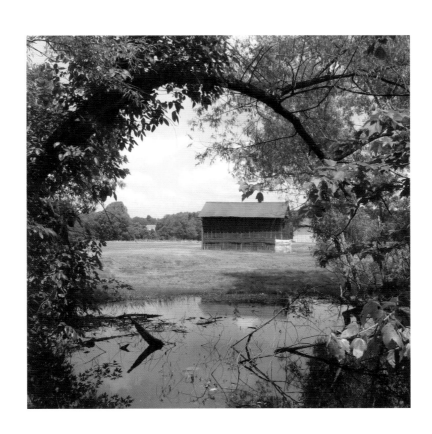

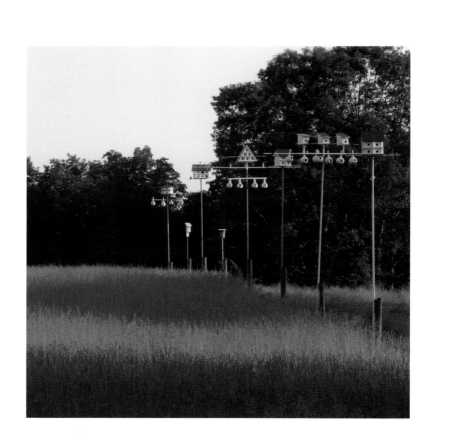

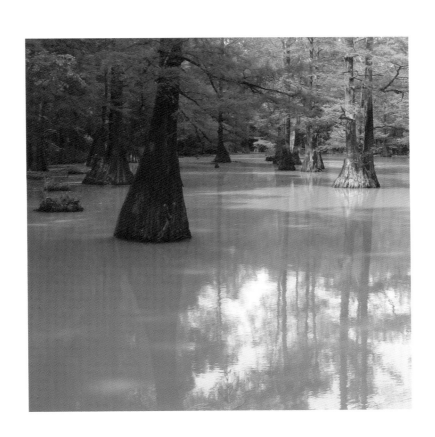

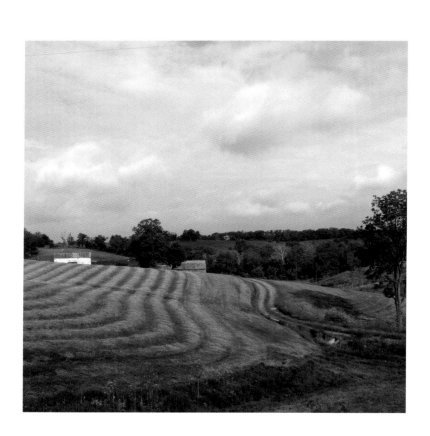

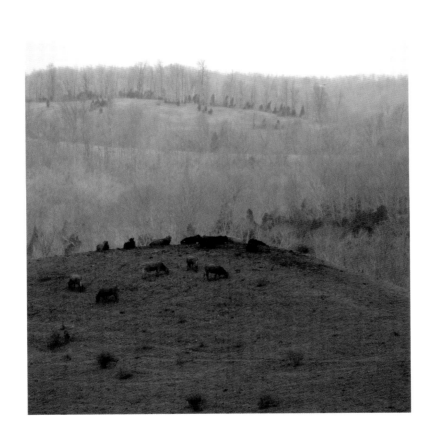

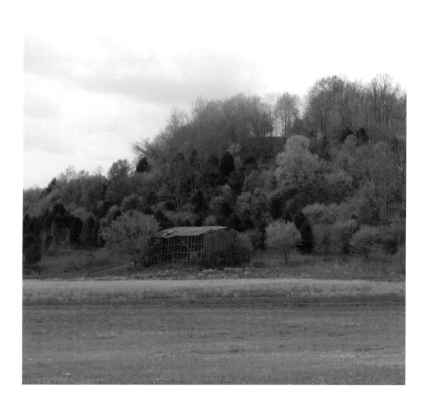

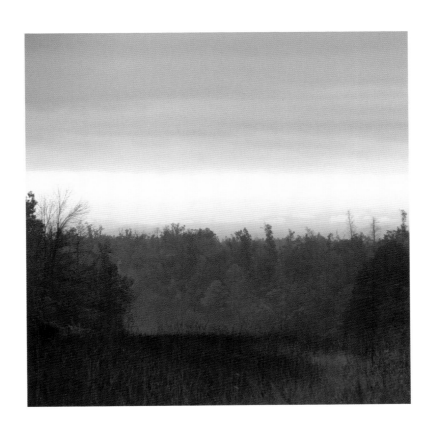

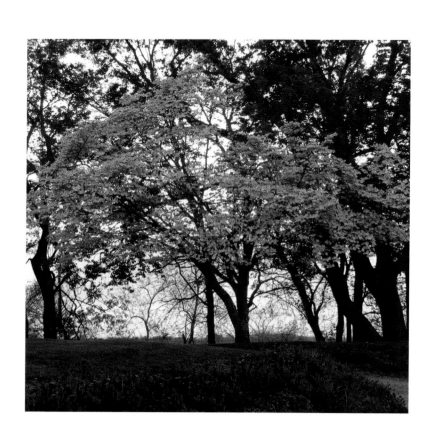

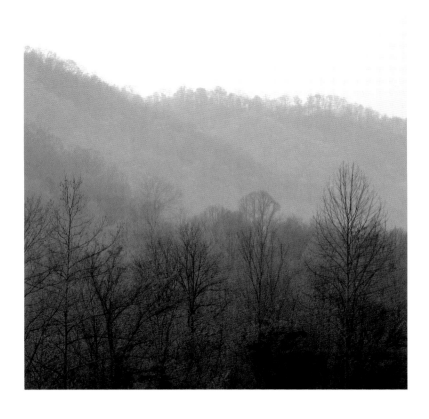

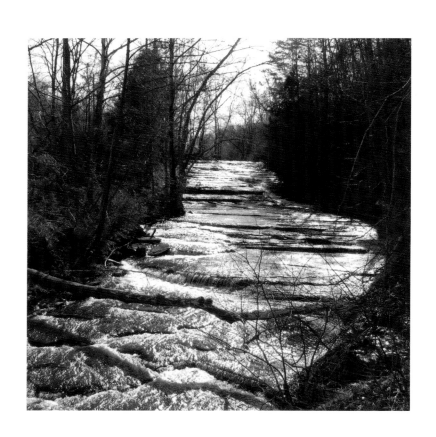

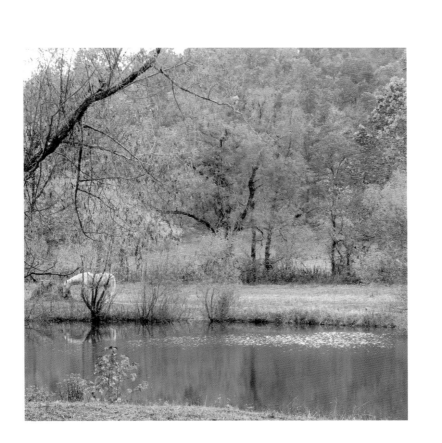

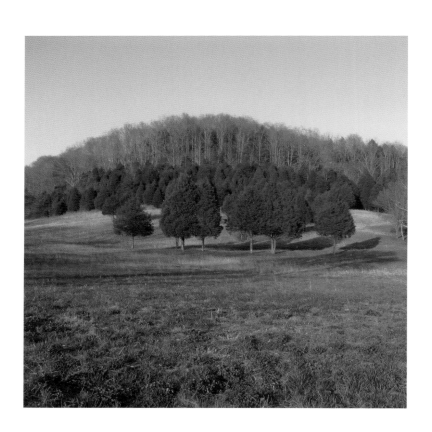

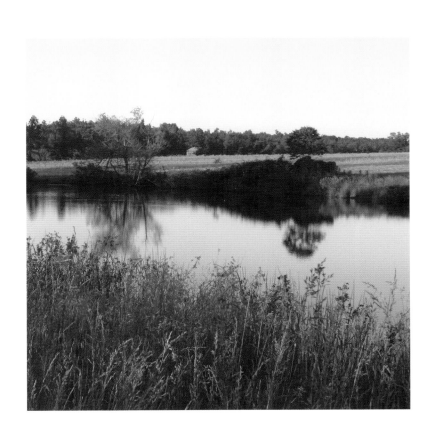

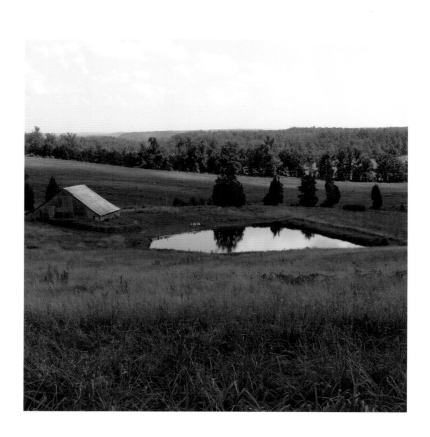

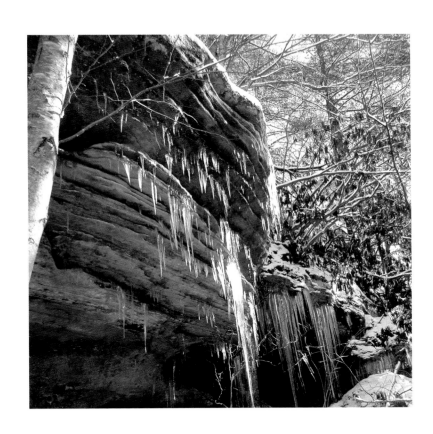

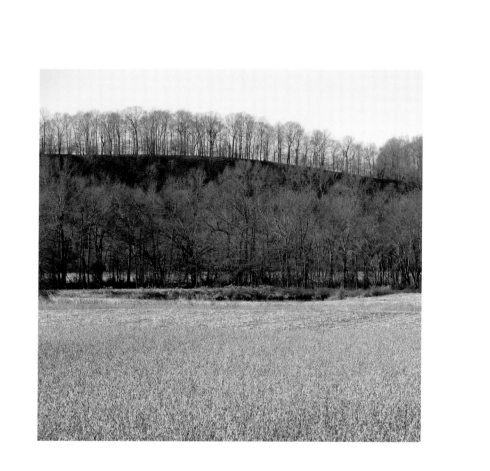

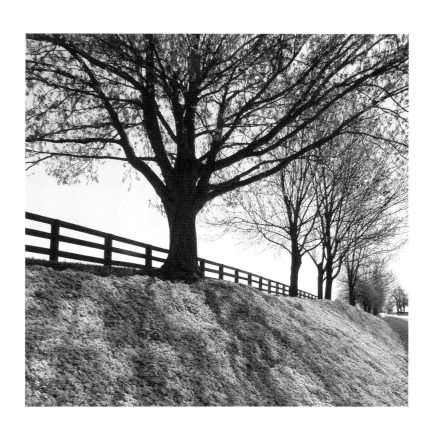

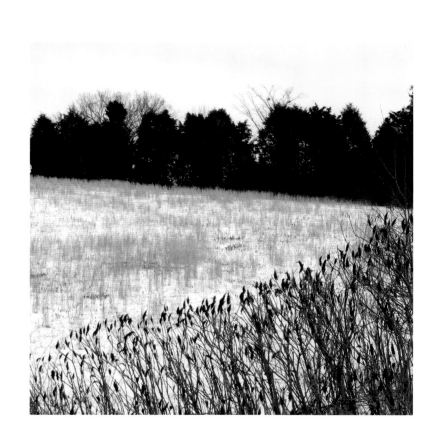

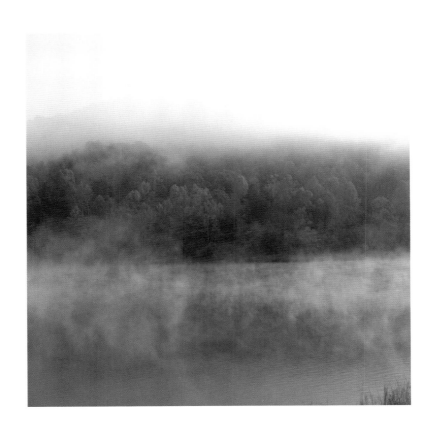

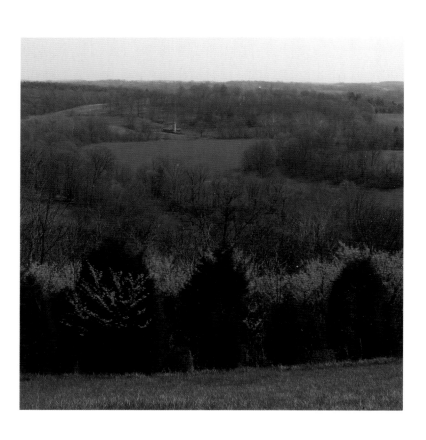

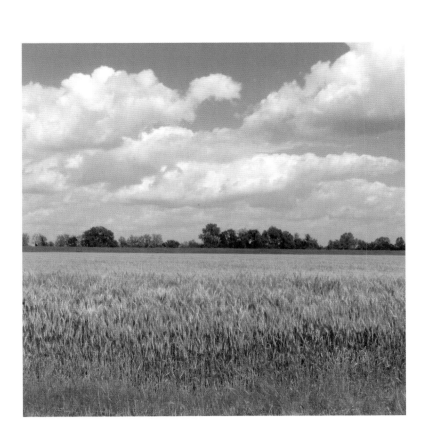

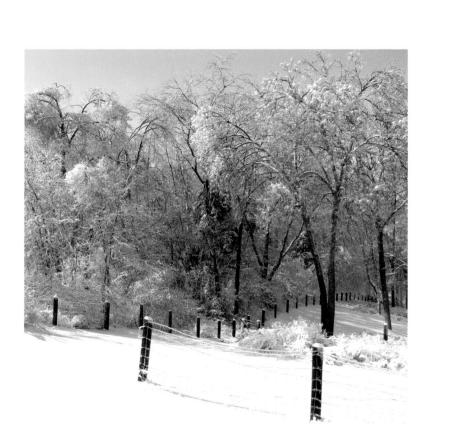

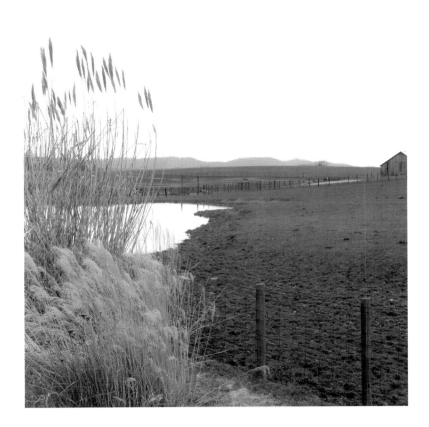

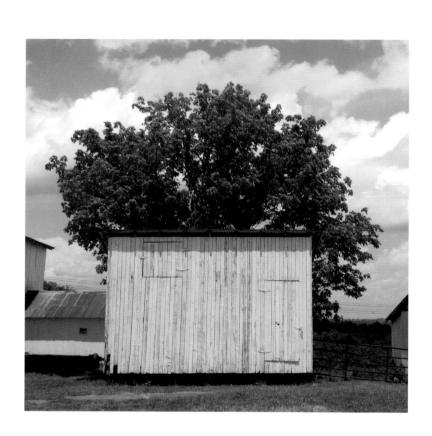

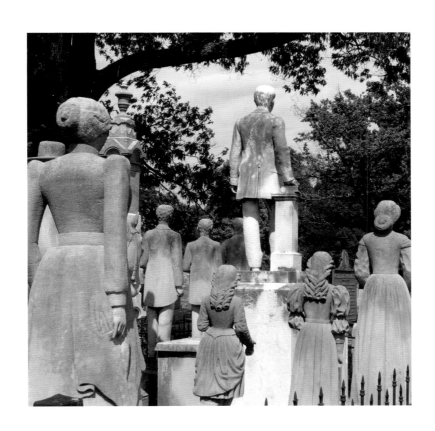

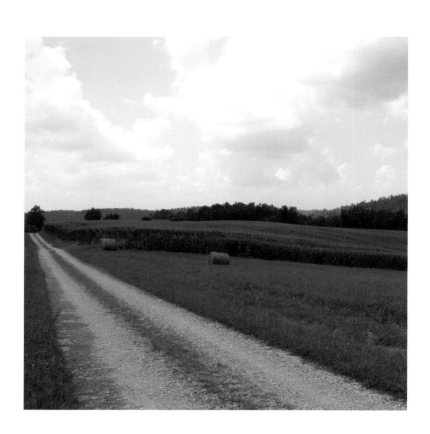

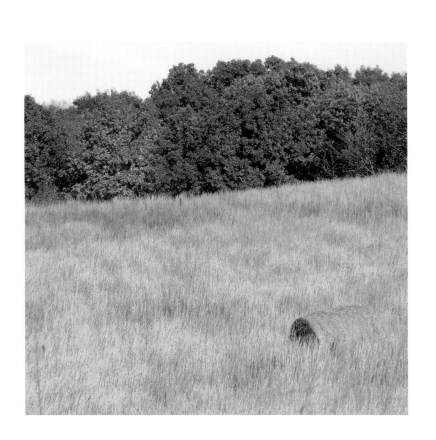

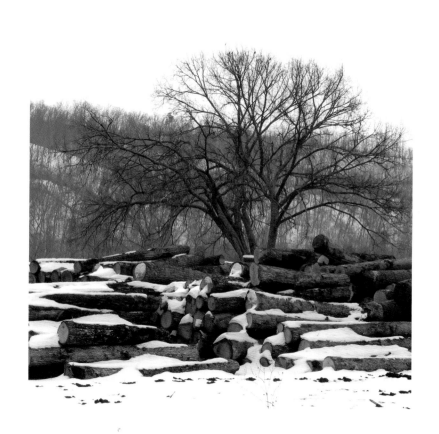

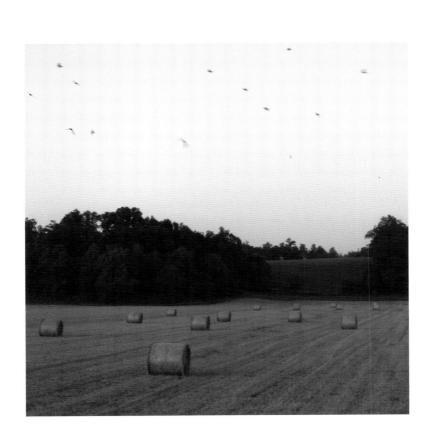

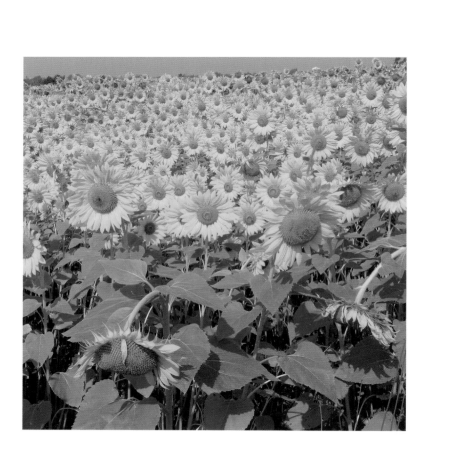

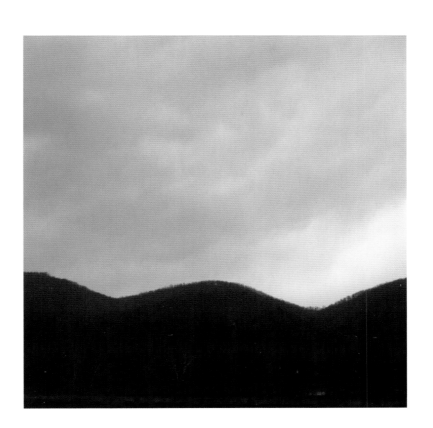

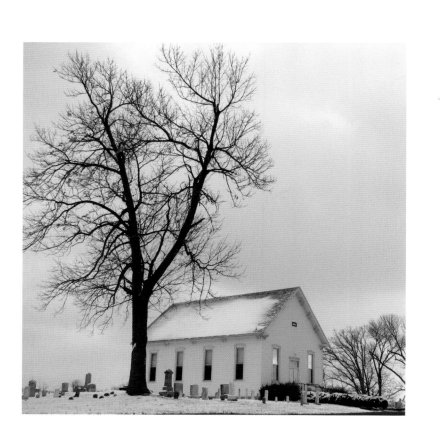

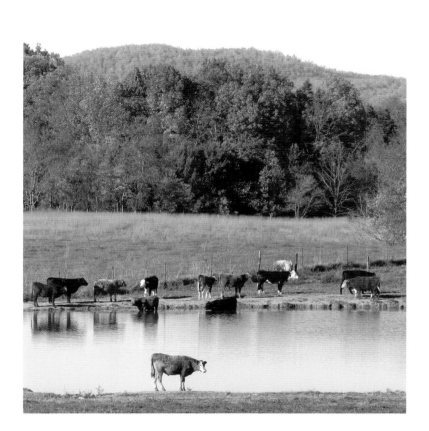

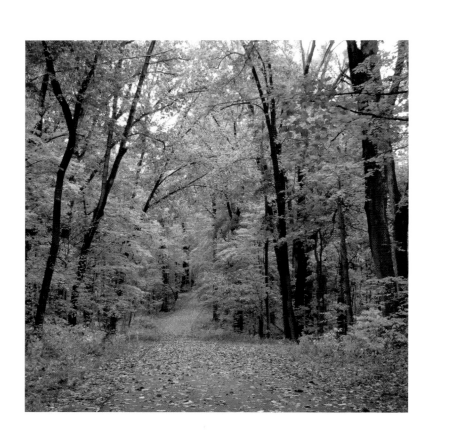

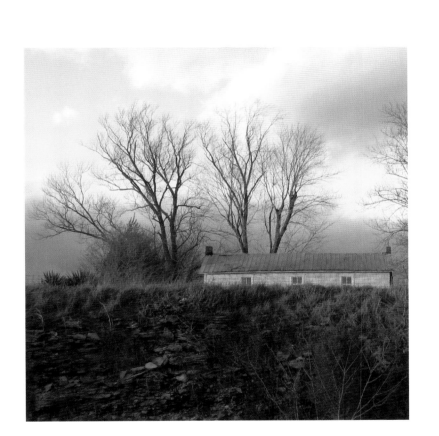

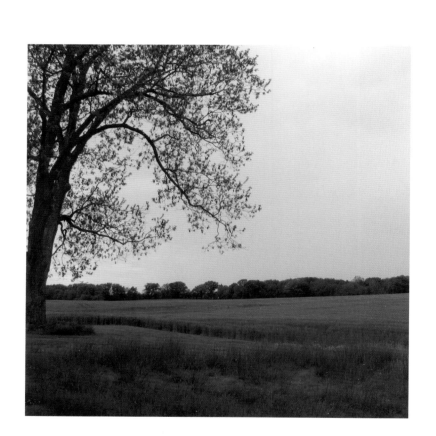

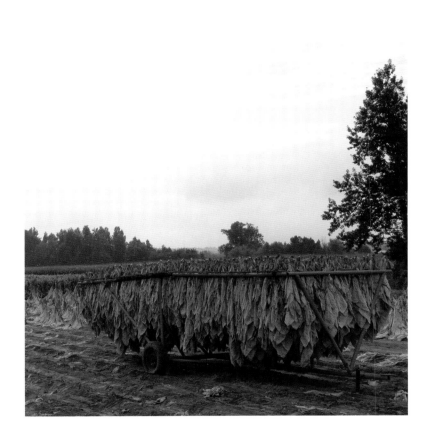

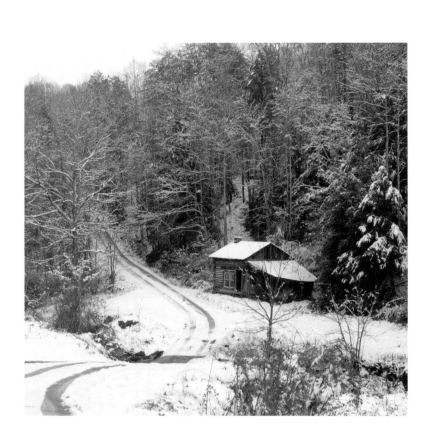

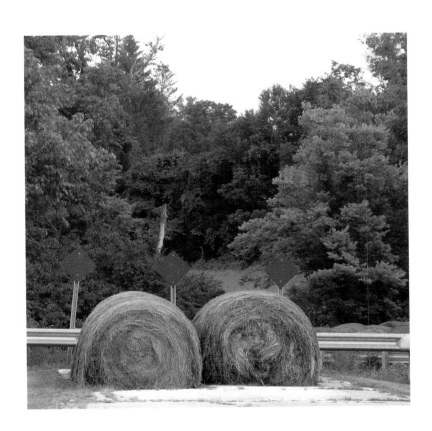

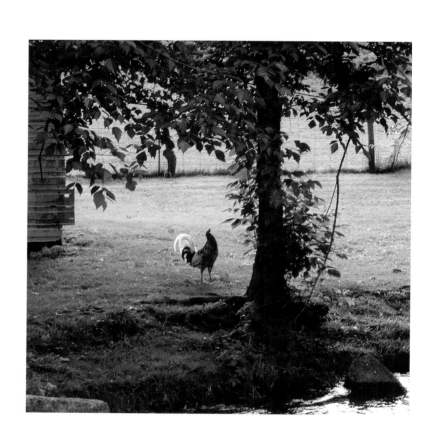

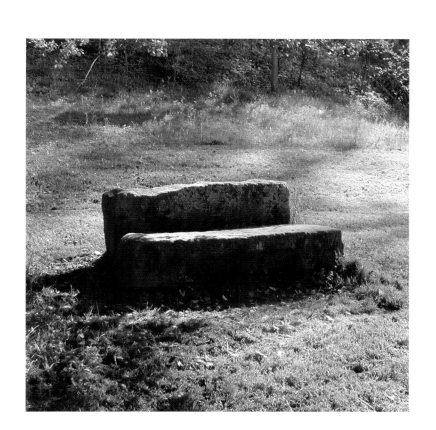

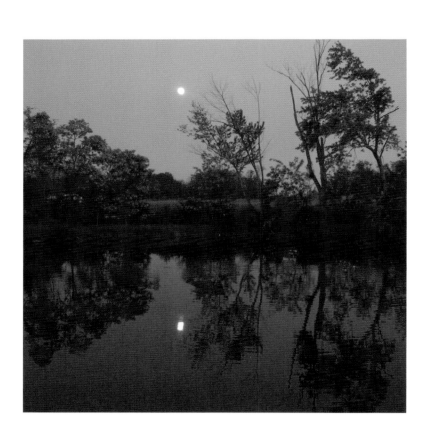

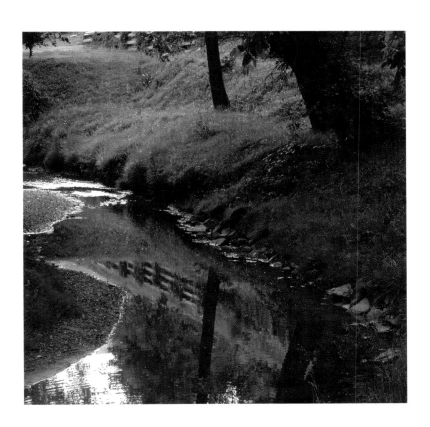

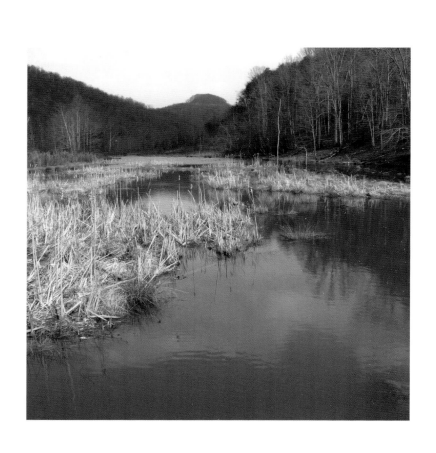

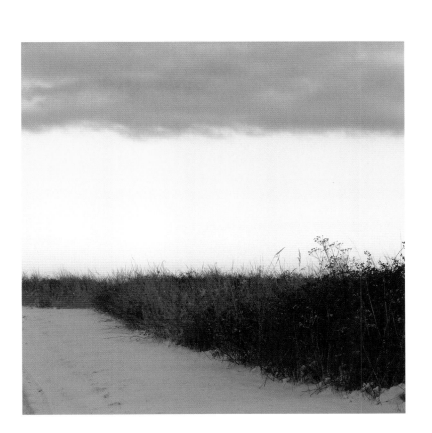

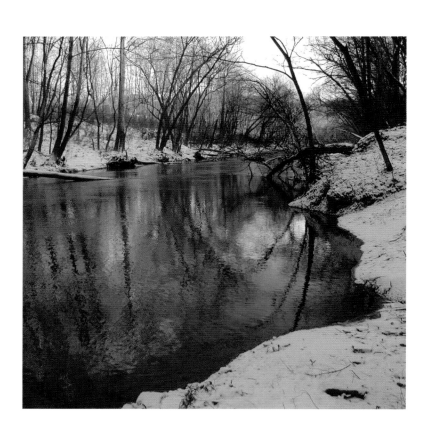

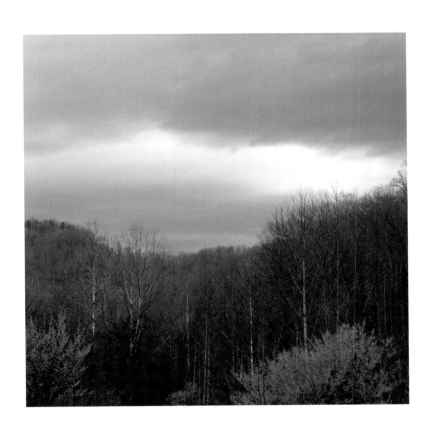

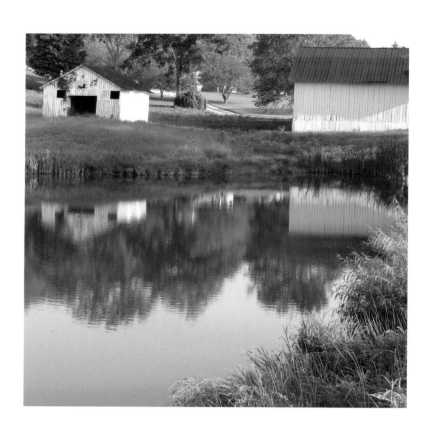

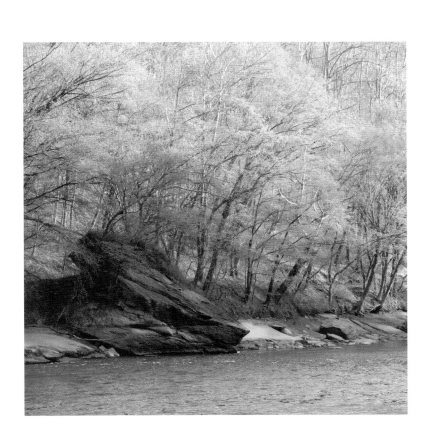

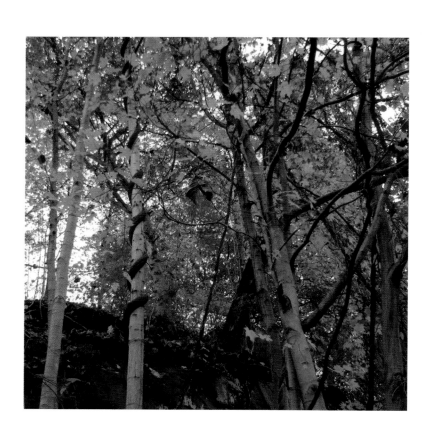

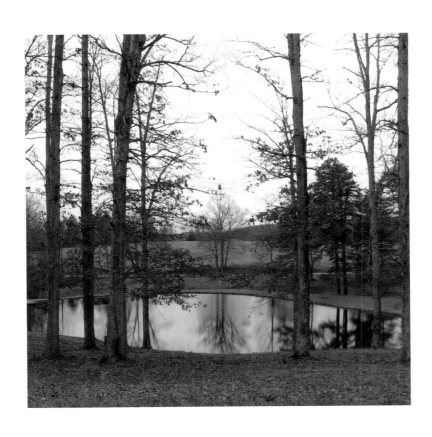

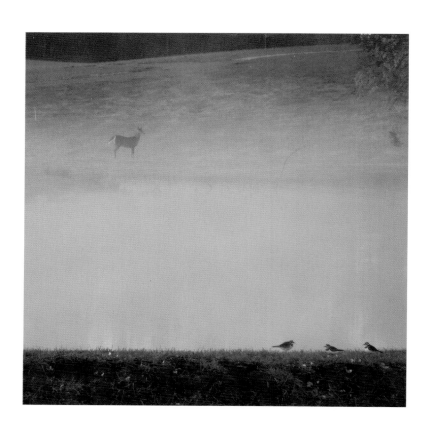

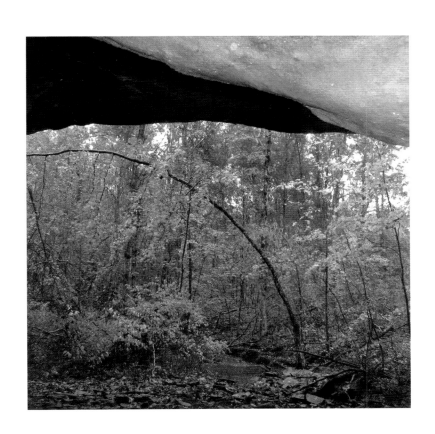

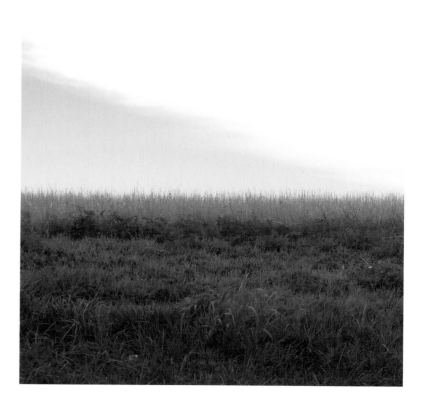

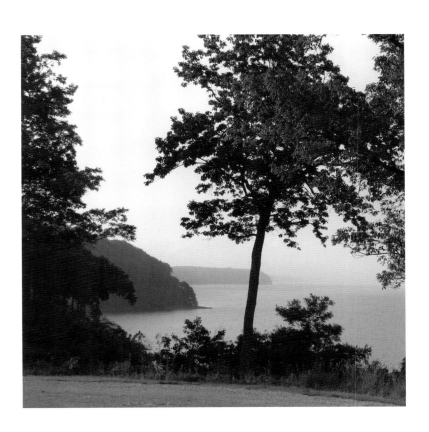

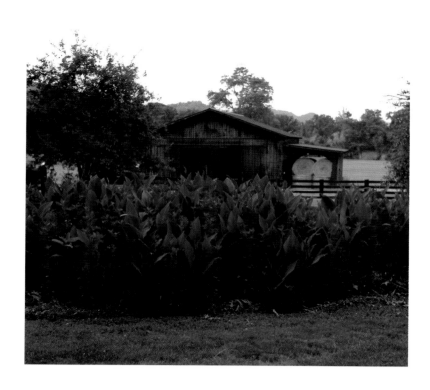

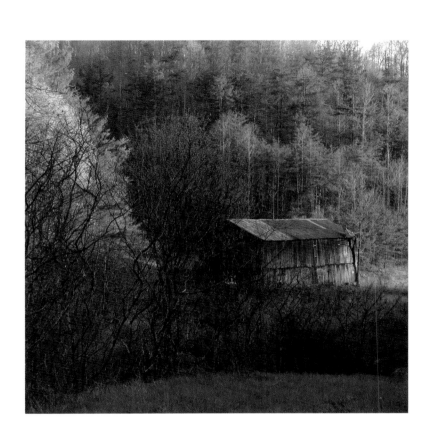

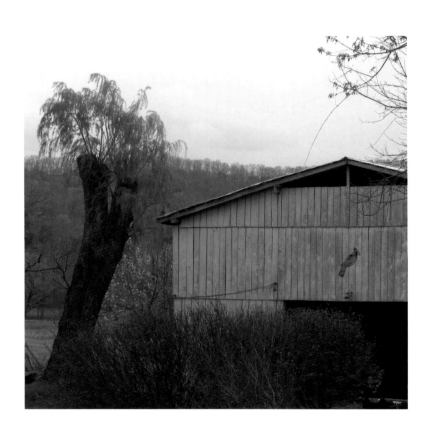

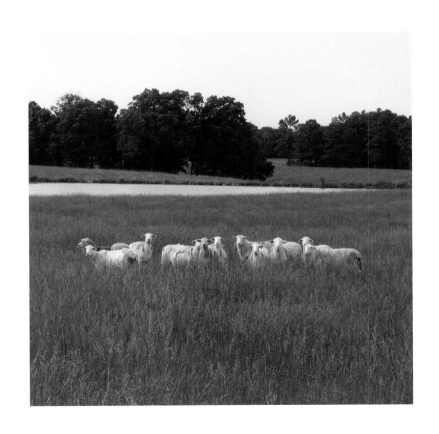

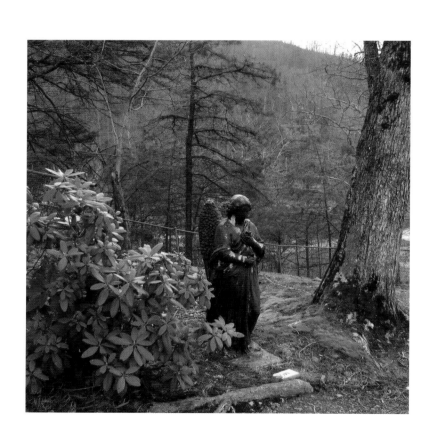

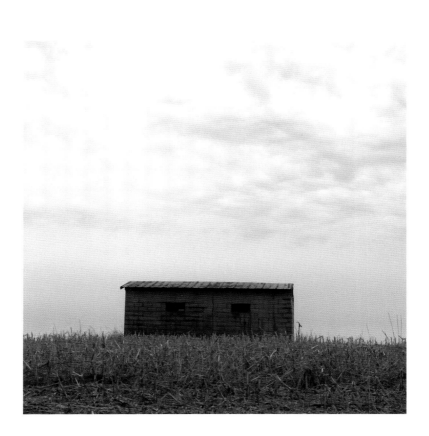

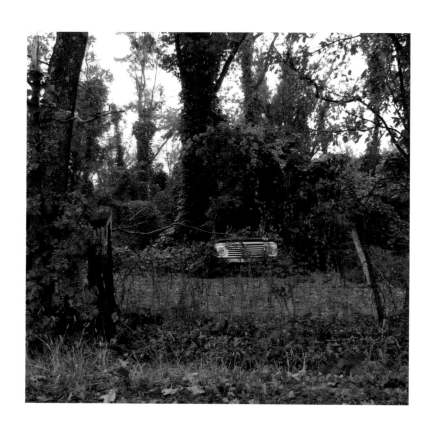

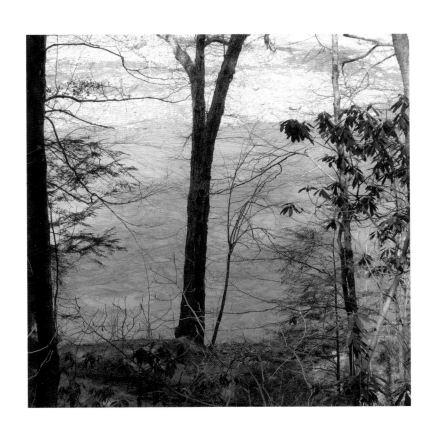

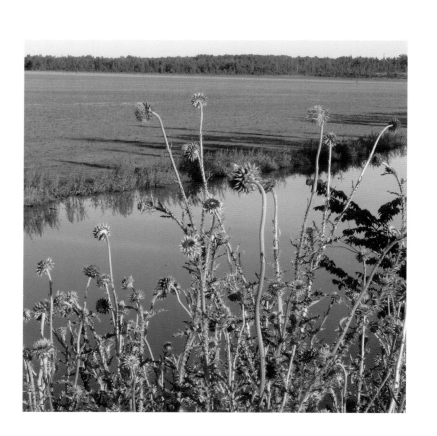

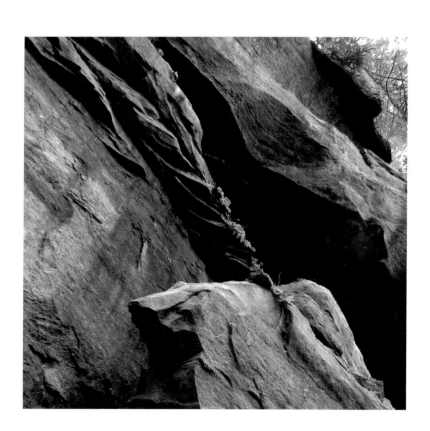

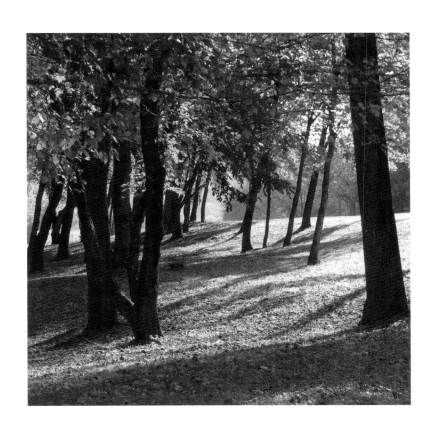

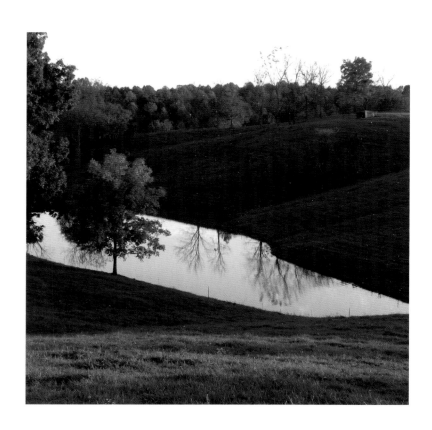

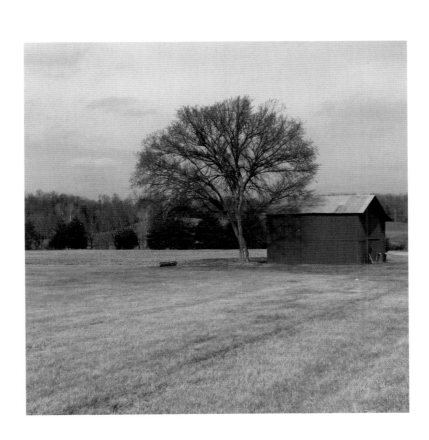

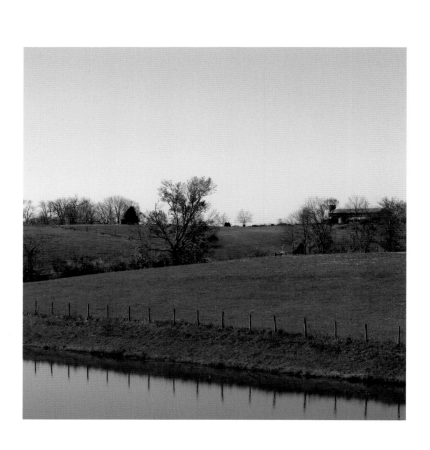

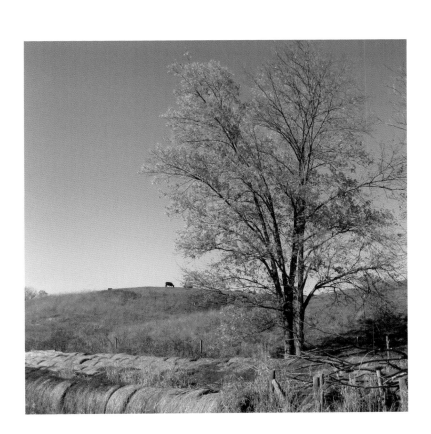

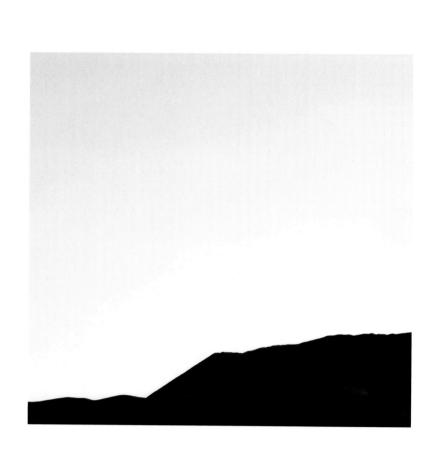

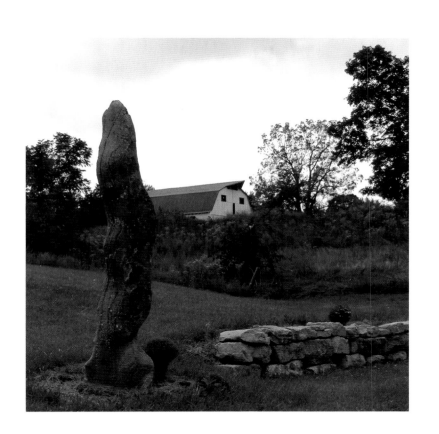

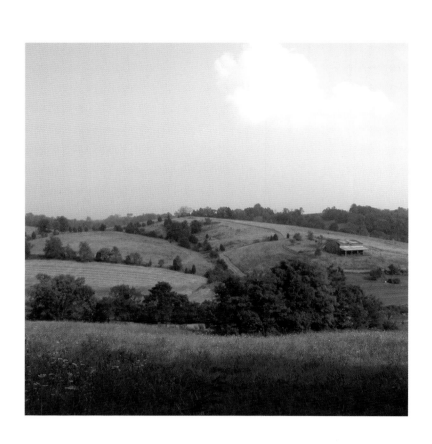

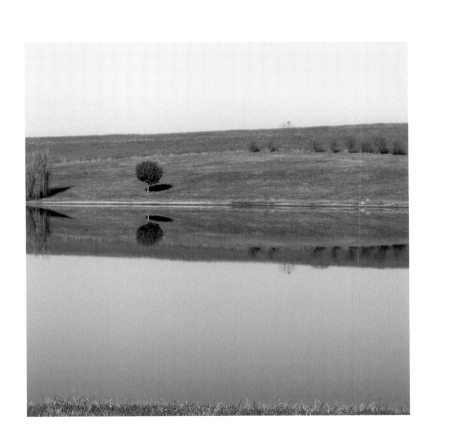

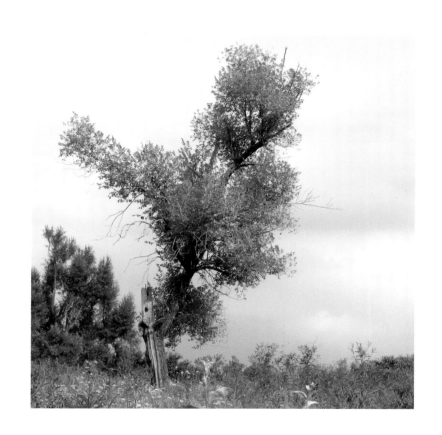

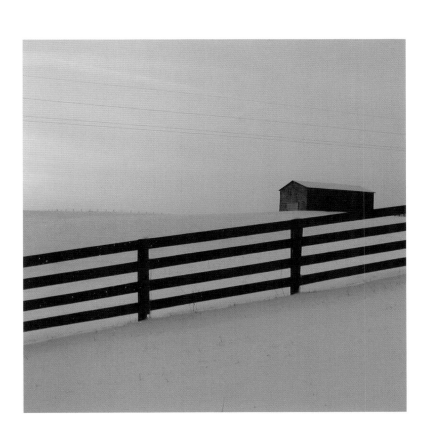

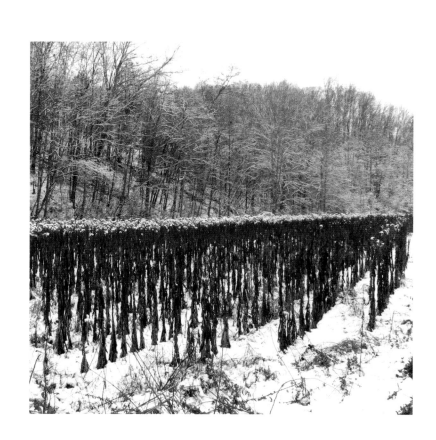

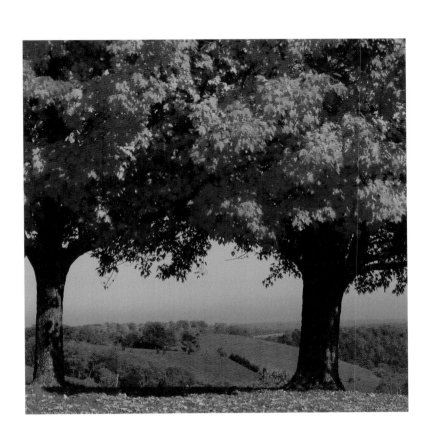

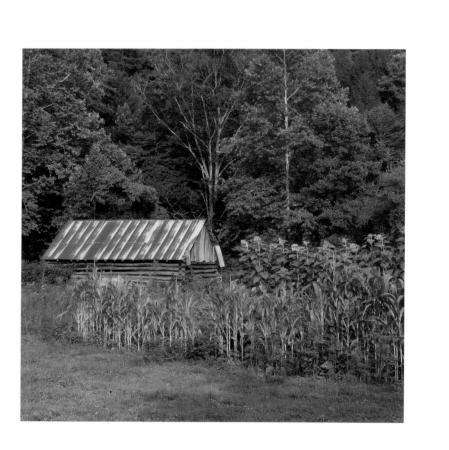

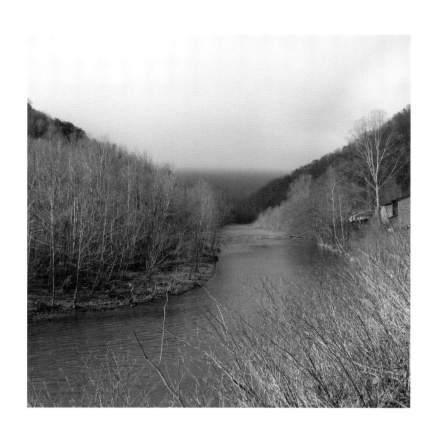

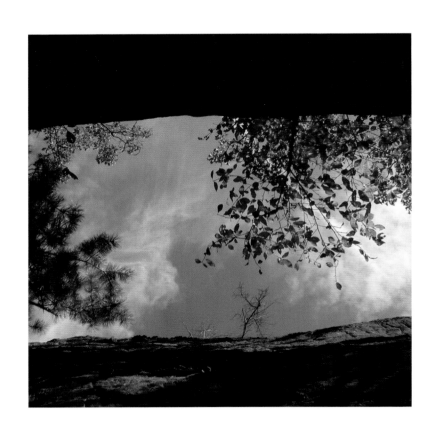

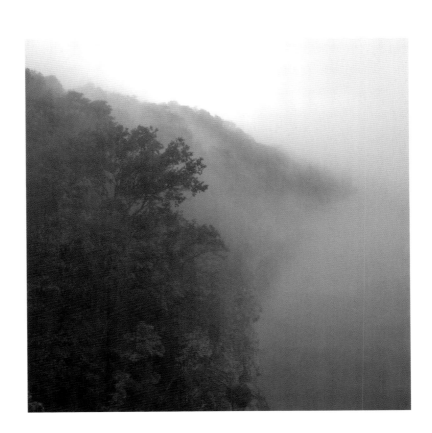

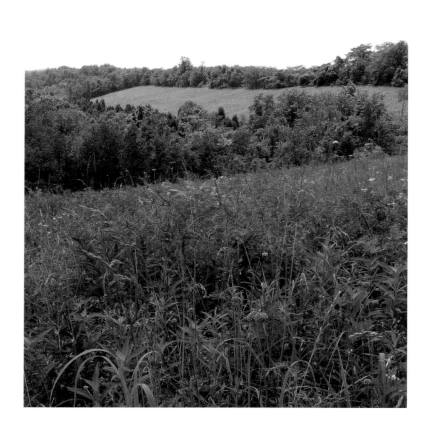

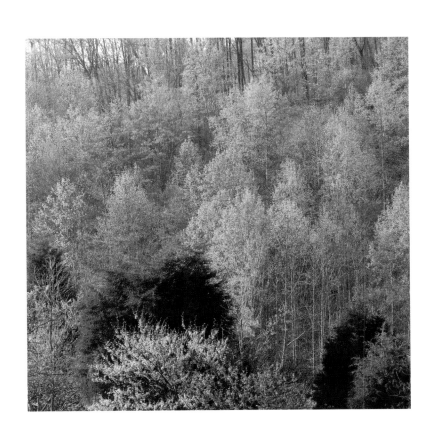

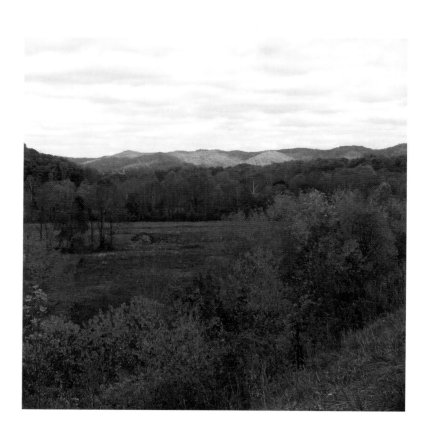

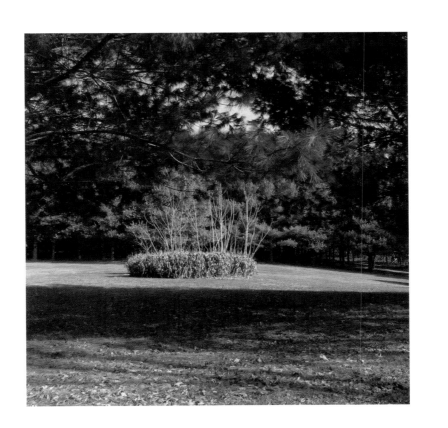

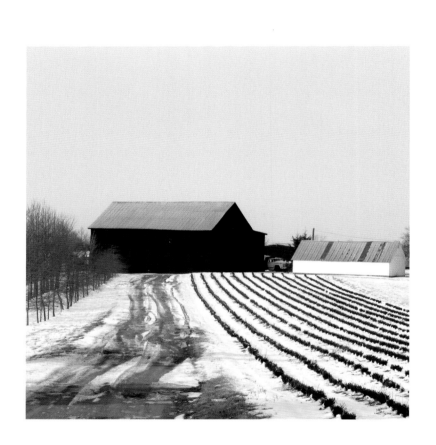

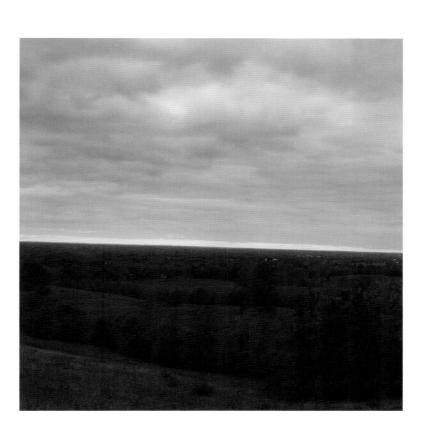

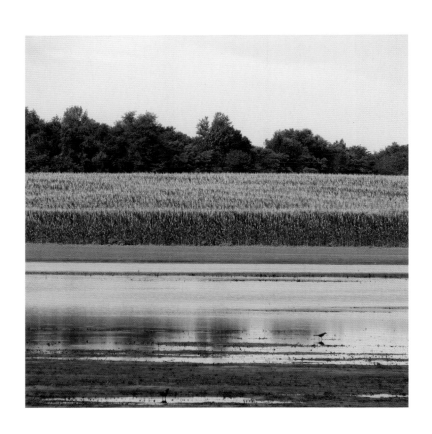

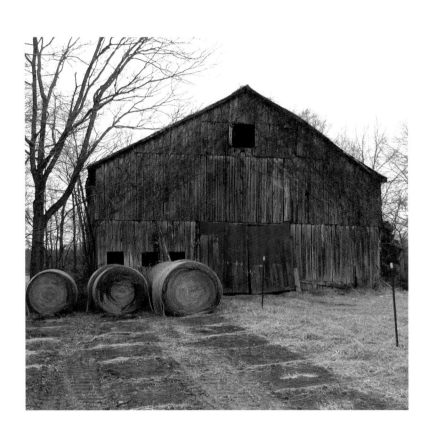

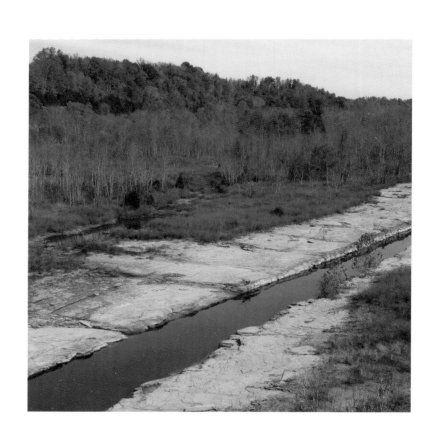

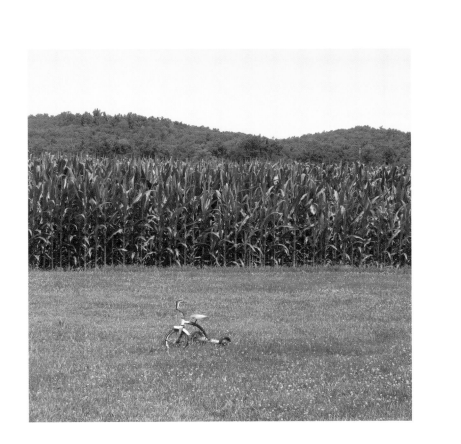

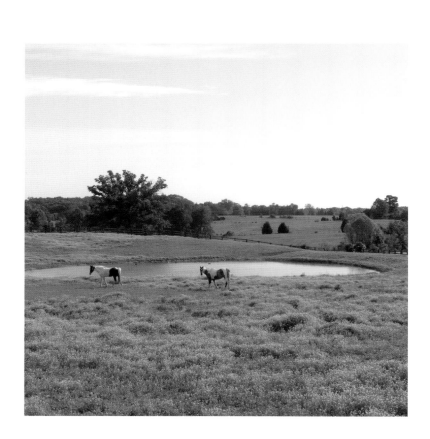

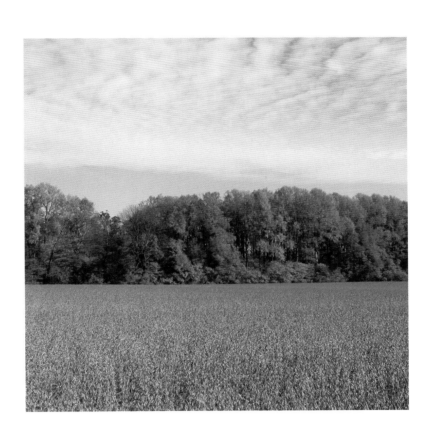

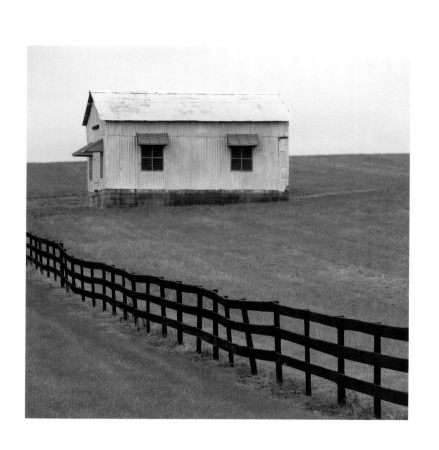

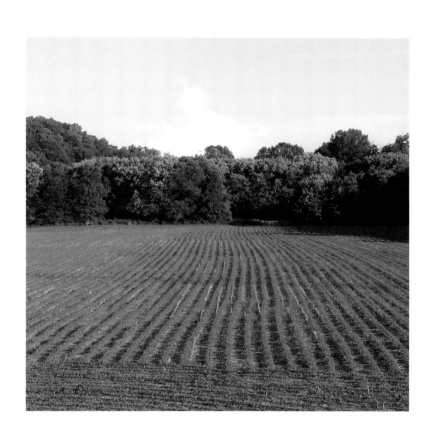

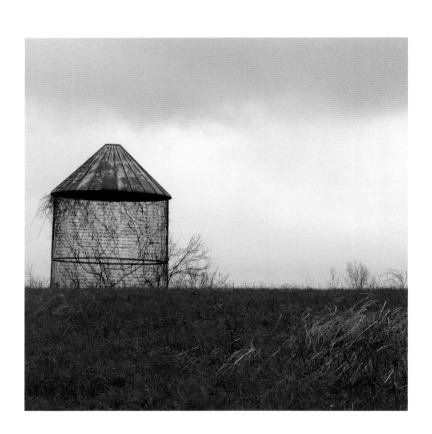

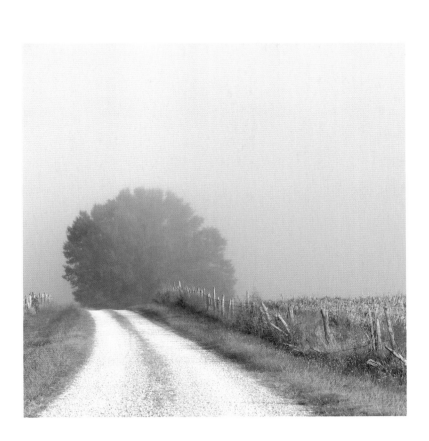

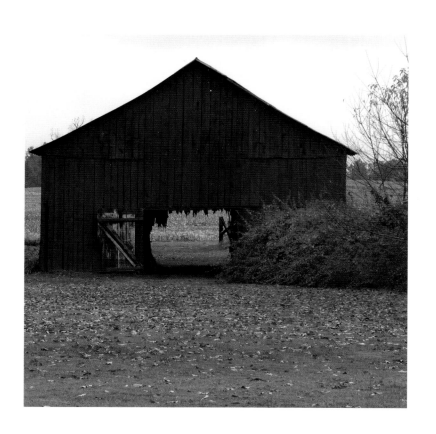

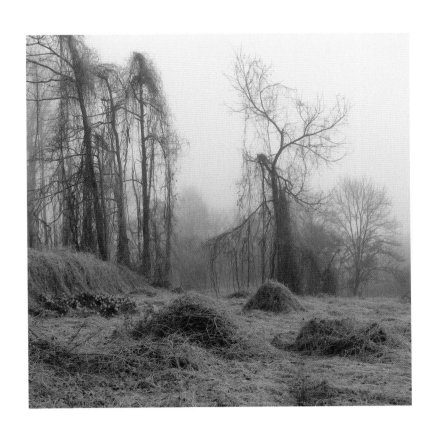

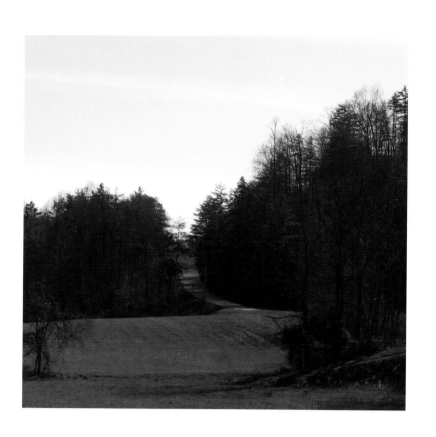

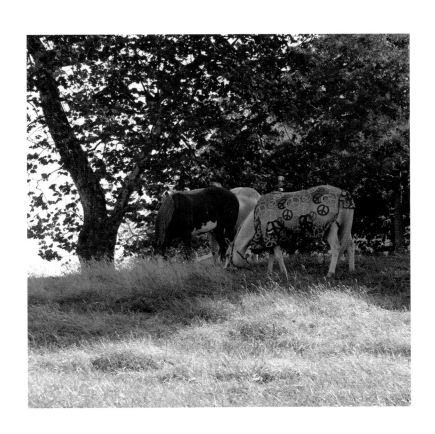

Adair County
April 6, 2009

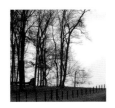

Allen County
March 7, 2009

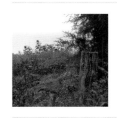

Anderson County
August 26, 2004

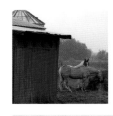

Ballard County
October 27, 2009

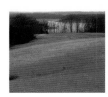

Barren County
March 7, 2009

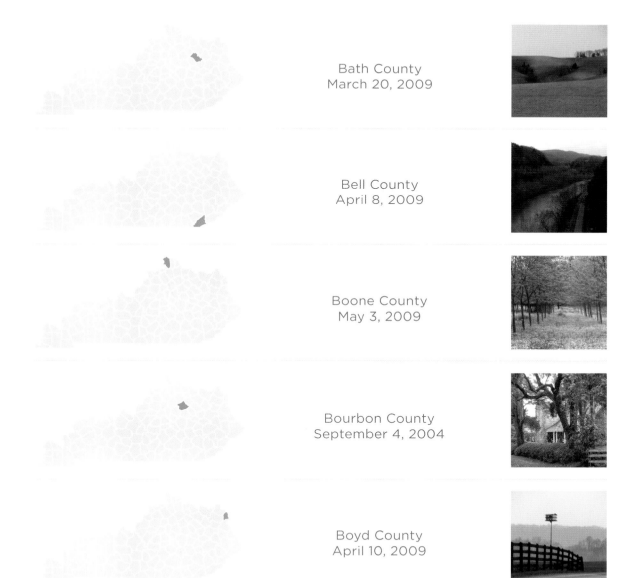

Bath County
March 20, 2009

Bell County
April 8, 2009

Boone County
May 3, 2009

Bourbon County
September 4, 2004

Boyd County
April 10, 2009

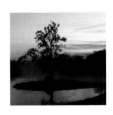

Boyle County
October 26, 2009

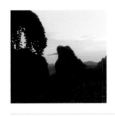

Bracken County
March 28, 2009

Breathitt County
August 14, 2010

Breckinridge County
November 10, 2013

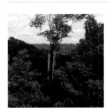

Bullitt County
July 3, 2009

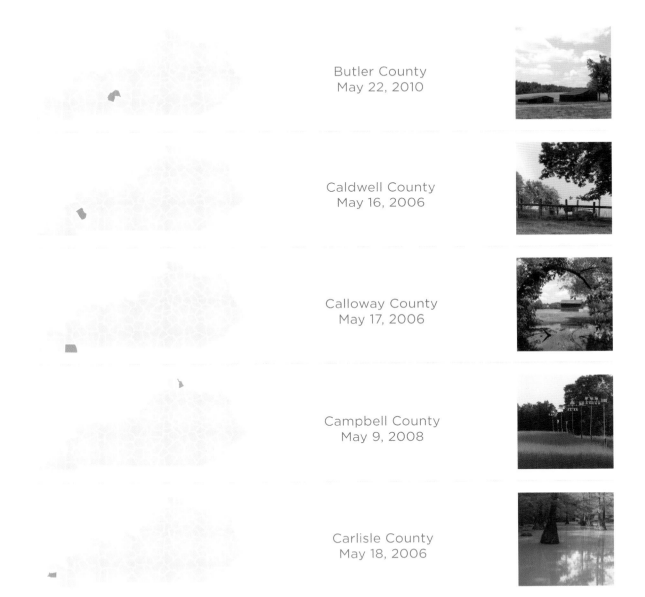

Butler County
May 22, 2010

Caldwell County
May 16, 2006

Calloway County
May 17, 2006

Campbell County
May 9, 2008

Carlisle County
May 18, 2006

Carroll County
May 25, 2009

Carter County
March 27, 2009

Casey County
April 19, 2008

Christian County
October 28, 2009

Clark County
April 15, 2010

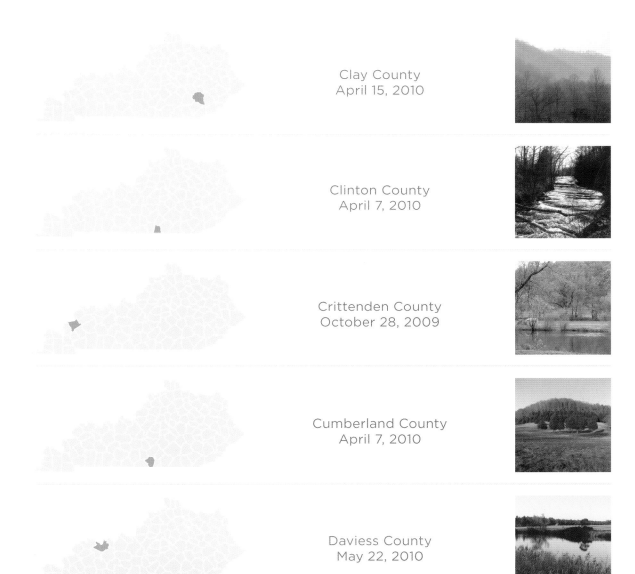

Clay County
April 15, 2010

Clinton County
April 7, 2010

Crittenden County
October 28, 2009

Cumberland County
April 7, 2010

Daviess County
May 22, 2010

Edmonson County
August 9, 2009

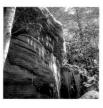

Elliott County
January 10, 2004

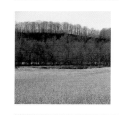

Estill County
November 26, 2006

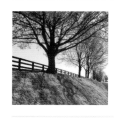

Fayette County
April 17, 2005

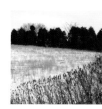

Fleming County
January 10, 2010

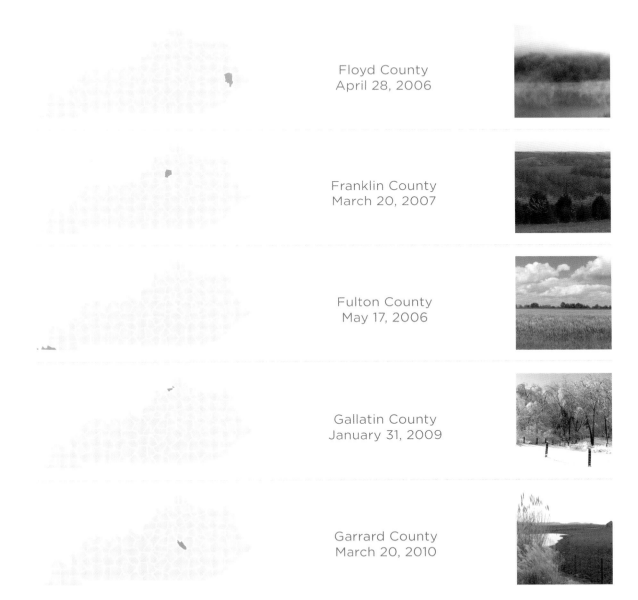

Floyd County
April 28, 2006

Franklin County
March 20, 2007

Fulton County
May 17, 2006

Gallatin County
January 31, 2009

Garrard County
March 20, 2010

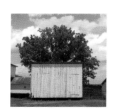

Grant County
June 10, 2008

Graves County
May 19, 2006

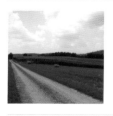

Grayson County
August 9, 2009

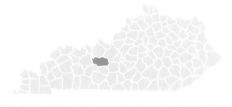

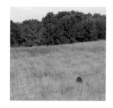

Green County
October 26, 2009

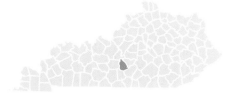

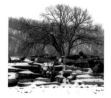

Greenup County
February 20, 2010

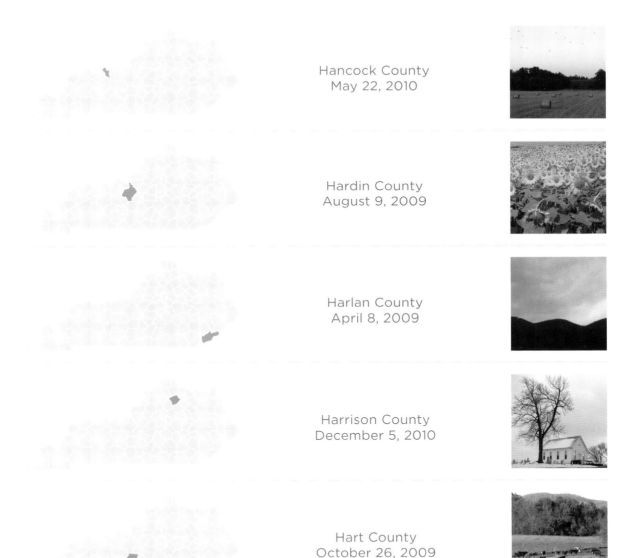

Hancock County
May 22, 2010

Hardin County
August 9, 2009

Harlan County
April 8, 2009

Harrison County
December 5, 2010

Hart County
October 26, 2009

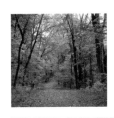

Henderson County
November 2, 2009

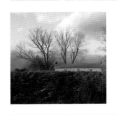

Henry County
December 23, 2007

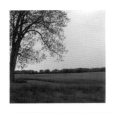

Hickman County
May 13, 2008

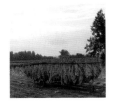

Hopkins County
August 17, 2013

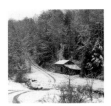

Jackson County
December 13, 2008

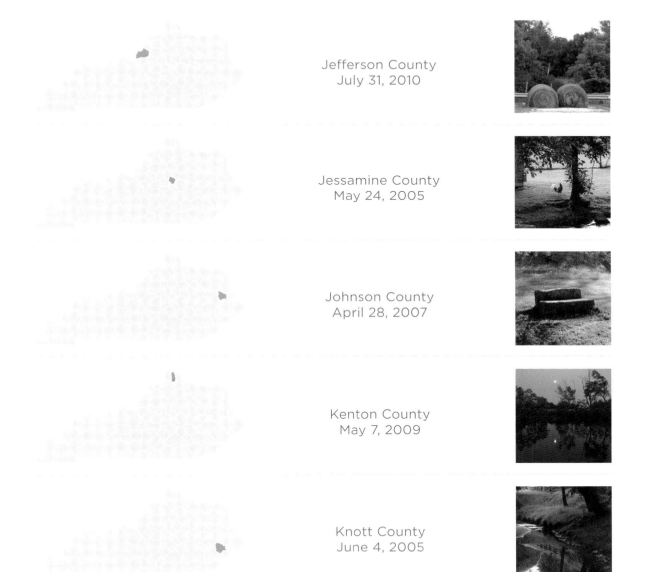

Jefferson County
July 31, 2010

Jessamine County
May 24, 2005

Johnson County
April 28, 2007

Kenton County
May 7, 2009

Knott County
June 4, 2005

Knox County
April 8, 2009

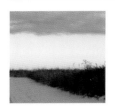

LaRue County
January 22, 2011

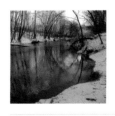

Laurel County
January 23, 2005

Lawrence County
April 10, 2009

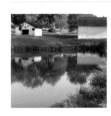

Lee County
August 14, 2010

Leslie County
April 15, 2010

Letcher County
October 28, 2006

Lewis County
March 27, 2009

Lincoln County
October 26, 2009

Livingston County
October 27, 2009

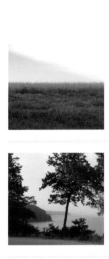

Logan County
June 19, 2010

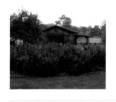

Lyon County
May 17, 2006

Madison County
June 16, 2013

Magoffin County
April 14, 2006

Marion County
April 19, 2008

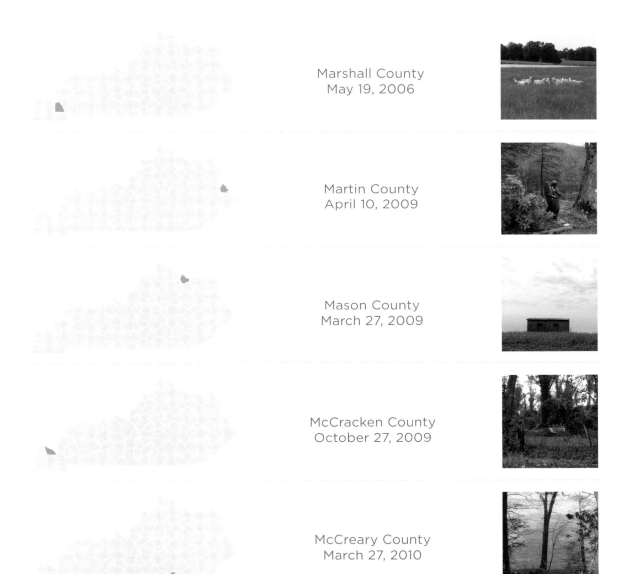

Marshall County
May 19, 2006

Martin County
April 10, 2009

Mason County
March 27, 2009

McCracken County
October 27, 2009

McCreary County
March 27, 2010

McLean County
May 22, 2010

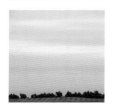

Meade County
July 3, 2009

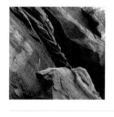

Menifee County
October 29, 2009

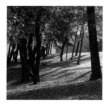

Mercer County
October 21, 2009

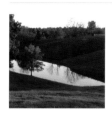

Metcalfe County
October 18, 2006

Monroe County
March 7, 2009

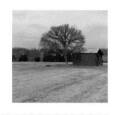

Montgomery County
November 1, 2009

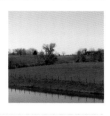

Morgan County
November 1, 2009

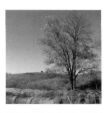

Muhlenberg County
May 22, 2010

Nelson County
August 23, 2004

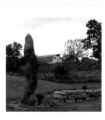

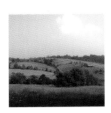

Nicholas County
September 5, 2004

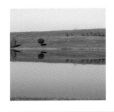

Ohio County
November 12, 2010

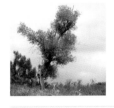

Oldham County
July 31, 2010

Owen County
January 11, 2005

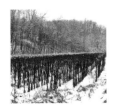

Owsley County
December 13, 2008

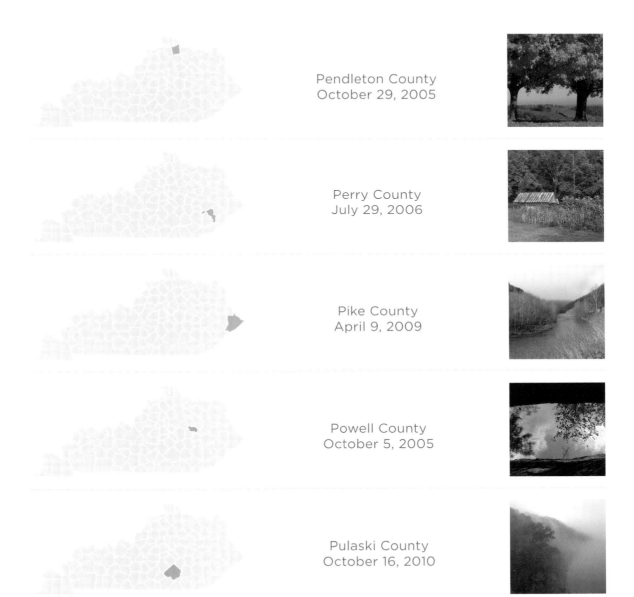

Pendleton County
October 29, 2005

Perry County
July 29, 2006

Pike County
April 9, 2009

Powell County
October 5, 2005

Pulaski County
October 16, 2010

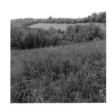

Robertson County
July 6, 2008

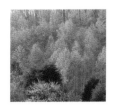

Rockcastle County
May 25, 2009

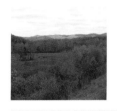

Rowan County
October 24, 2006

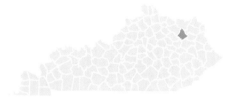

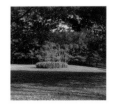

Russell County
November 26, 2006

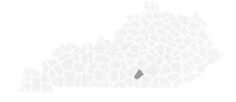

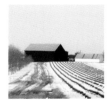

Scott County
February 14, 2010

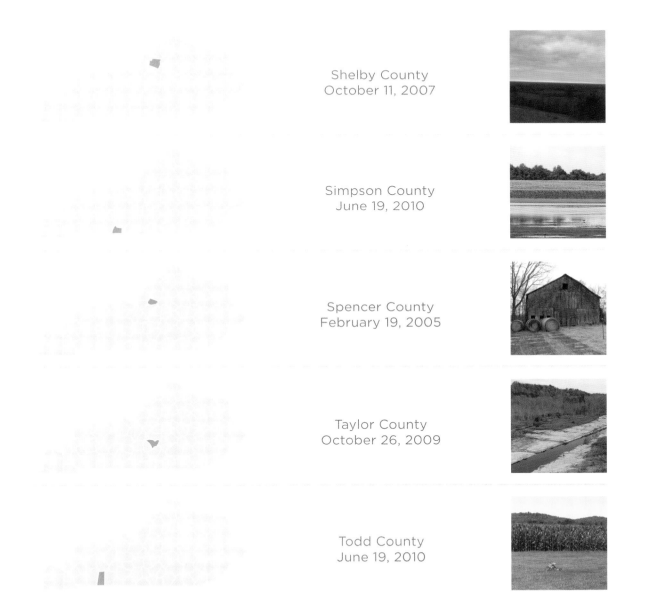

Shelby County
October 11, 2007

Simpson County
June 19, 2010

Spencer County
February 19, 2005

Taylor County
October 26, 2009

Todd County
June 19, 2010

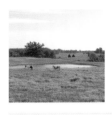

Trigg County
May 13, 2008

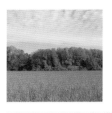

Trimble County
October 26, 2004

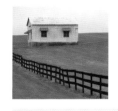

Union County
October 28, 2009

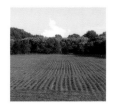

Warren County
June 19, 2010

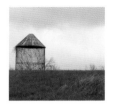

Washington County
April 6, 2009

Wayne County
October 16, 2010

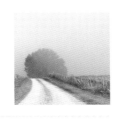

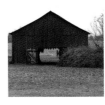

Webster County
October 28, 2009

Whitley County
March 27, 2010

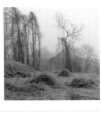

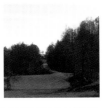

Wolfe County
April 9, 2009

Woodford County
October 21, 2012

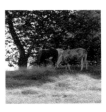

ED LAWRENCE has explored many visual art media and always returned to photography for artistic expression. He received his first camera for his ninth birthday. It was a Kodak Brownie with a flash attachment. His parents never really understood at that time why he took pictures of everything except people. He wanted to photograph shapes and patterns that interested him. His best friend's house had a darkroom, and as a boy, Ed spent many hours in that red-lit room exploring the magic of developing film and making prints.

While studying fine art in college, it was the photography projects that helped Ed understand abstraction. As a young graphic designer, he maintained his interest in photography but put his Nikon 35mm camera aside and started using a Kodak Instamatic. It was inexpensive, pocket-sized, easy to use and perfect for capturing the unique architectural patterns and design details in his city environment.

When the Polaroid Land Camera SX70 became popular, Ed fell in love with the instant gratification, harking back to the darkroom days of watching a print magically develop. Mistakes could be made and corrected in the next shot with the Polaroid. It was an experimental format with less emphasis on detail but more focus on color, texture and form in his compositions.

Photography fell to the wayside as Ed Lawrence advanced his professional career and became very busy as the father of two boys. His oldest son, when in high school, found the old Nikon camera tucked away in a closet and took an interest in photography. It became a father-and-son activity for the pair to ride around country roads chasing sunsets — the son with the film camera and the father with a digital camera. Ed became hooked on photography once again.

Digital photography provides all the elements that have drawn Ed Lawrence to the medium throughout his life. Not a photographer's photographer, he could care less about the world of apertures, f-stops, ISOs and metering. Ed Lawrence just uses a camera to paint what he sees.

SPECIAL THANKS to my wife Sandie Lawrence, my love and my helpmate who is always there for me and always believes in me . . . to my son Aaron Lawrence, for being a better photographer than me . . . to my son Kyle Lawrence, for having a glitter pocket . . . to my sister Pat Lawrence for joining fellow artists Arturo Alonzo Sandoval and Marianna McDonald in being curators for the KENTUCKY 120 Collection . . . to the farmers of Kentucky for shaping beautiful landscapes and to the many individuals, organizations and government entities for preserving the natural landscapes of our commonwealth . . . to Bill Monroe and Ben Sollee who traveled with me via CD recordings as I searched for Kentucky landscapes . . . to Celeste Lewis for being excited about this body of work and bringing it to Alfalfa Restaurant for the preview exhibit . . . to my grandniece Tyler Belle Nelson for being my backroads videographer . . . to my friend and neighbor Sandra Altom for playing "My Old Kentucky Home" on the piano . . . to Emily Moses for helping me figure it all out through the interview process . . . to Katie Lewis for being the queen of fonts . . . to Mark Brown for last-minute editing. . . to Melissa Oesch for her collaboration in designing and creating the five limited edition art books of KENTUCKY 120. . . to Jean Donohue, Heath Eric, Griffin VanMeter, Karine Maynard and Marcie Christensen for their crowdsource funding and social media experience sharing . . . to Laurel Christensen, Arturo Alonzo Sandoval, Celeste Lewis, Fran Redmon, Linda Green, Katie Lewis, Nancy Atcher, Marcie Christensen, Pat Lawrence, Marianna McDonald, Emily Moses, Tona Barkley and Art Mize for being great video endorsers . . . to John Harrod, Lucian Parker, Tommy Case and Art Mize for being some of the best fiddlers in Kentucky . . . to Donna Sue Groves for her sincerity and early encouragement . . . to Sarah Schmitt for being first . . . to Todd Lowe for being a game changer and not letting the fat lady sing . . . to my cousin Linda Green, for being intrigued by crowdsource funding . . . to my son Aaron Lawrence, for creating the excitement of victory and . . . to my brother Dennis Ogden, who issued the ultimate challenge, which made KENTUCKY 120 happen.

SIGNIFICANT SUPPORT

Sandra and David Altom, Frankfort, Kentucky

Philis Alvic and Gary Schroeder, Lexington, Kentucky

Candice and Peter Angelus, Alexandria, Virginia

Nancy Atcher, Frankfort, Kentucky

Tona Barkley, Monterey, Kentucky

Katie Bean, Mount Juliet, Tennessee

Leslie Brady Bishop, Frankfort, Kentucky

Traci Boyd, Lexington, Kentucky

Stacey, Kennedy, Emma and Abby Brand, Villa Hills, Kentucky

Linda Key Breathitt, Lexington, Kentucky

Irene M. Burnett, Lexington, Kentucky

Kim Butterweck, Louisville, Kentucky

Craig Cahoon and Kathy Walters, Washington, D.C.

Charles B. Camp, Georgetown, Kentucky

Chris Cathers and Misty Jones, Lexington, Kentucky

SIGNIFICANT SUPPORT

Bettye and Bill Cheeves, Lexington, Kentucky

Marcella Rose Christensen, Lawrenceburg, Kentucky

Barri and Arielle Christian, Frankfort, Kentucky

Pamela Clegg, Georgetown, Kentucky

Dorothy Cline, Georgetown, Kentucky

Tamara Coffey, Frankfort, Kentucky

Shelley and Marvin DeBell, Lexington, Kentucky

Milly Hudson Diehl, Ft. Mitchell, Kentucky

Jean Donohue, Portland, Oregon

Harriet Dupree Bradley, Lexington, Kentucky

Kristine R. Ehrich, San Diego, California

Heath and Molly G. Eric, Rumsey, Kentucky

Ellen Ferguson, Lexington, Kentucky

Ann K. Ferrell and Brent Bjorkman, Bowling Green, Kentucky

Andrea Fisher and Robert McNeely, Middletown, New York

SIGNIFICANT SUPPORT

Susan Goldstein, Lexington, Kentucky

J. P. and Rebecca Hanly, Frankfort, Kentucky

John Harrod, Monterey, Kentucky

Taylor and Joanna Hay, Frankfort, Kentucky

Vallorie Henderson, Louisville, Kentucky

Dennis and Ann Horn, Shelbyville, Kentucky

Michael and Christine Huskisson, Versailles, Kentucky

Gwenda and Gene Johnson, Sandy Hook, Kentucky

C. Charlotte Lakers, Lexington, Kentucky

Cay Lane, Mt. Sterling, Kentucky

Pat Lawrence, Lexington, Kentucky

JD Lester, Lexington, Kentucky

Katie Lewis, Frankfort, Kentucky

Joe Lilly, Louisville, Kentucky

Heather Lyons and David Long, Lexington, Kentucky

SIGNIFICANT SUPPORT

Alisha and Shawn Martin, Georgetown, Kentucky

Anthony Maxwell, Lexington, Kentucky

Matthew and Karine Maynard, Lawrenceburg, Kentucky

Joyce and Troy Mays, Lexington, Kentucky

Marianna McDonald, Lexington, Kentucky

James (Jim Bob) and Pam Oldfield Meade, White Oak, Kentucky

Lori Meadows, Midway, Kentucky

Kim Megginson and Brad Abbey, Kettering, Ohio

Janice Miller, Lancaster, Kentucky

Emily Moses, Frankfort, Kentucky

Marsha and Steve Moses, Cynthiana, Kentucky

Megan D. Murrey, Lexington, Kentucky

Mary and Dan Nehring, Versailles, Kentucky

Bill and Adrianne Nelson, Half Moon Bay, California

Douglas and Patricia Ogden, Boca Raton, Florida

SIGNIFICANT SUPPORT

Jacque Carter Parsley, Louisville, Kentucky

Sandra and Randall Polly, Lexington, Kentucky

Fran Redmon, Frankfort, Kentucky

Rona Roberts, Lexington, Kentucky

Richard Rosenbaum and Vilma Sanchez, Arnold, Maryland

Walter Roycraft, Lexington, Kentucky

Roberta Schulz, Wilder, Kentucky

Debbie Shannon and Steve Crews, Louisville, Kentucky

Michael A. Smith and Anne-Marie O'Keeffe, Yonkers, New York

John Snell, Lexington, Kentucky

Will Speilberg, Half Moon Bay, California

Kurt Gohde and Kate Sprengnether, Lexington, Kentucky

Carolyn and Robert Starbuck, Lexington, Kentucky

Diane Sulg, Mint Hill, North Carolina

Carole Summers Morris, Charlotte, North Carolina

SIGNIFICANT SUPPORT

Liz Swanson and Mike McKay, Lexington, Kentucky

Michael and Victoria Terra, Paducah, Kentucky

Ann Tower Gallery, Lexington, Kentucky

James and Kate Vermillion, Lexington, Kentucky

Elizabeth Helm and James R. Voyles, Louisville, Kentucky

Marcus Waldner and Kathryn Ford, Louisville, Kentucky

Steven Walsh, Dalzell, South Carolina

Jennifer L. Webb, Louisville, Kentucky

Shirley Whitescarver, Lexington, Kentucky

The Wileys, Middlesboro, Kentucky

Valerie Williams, Jacksonville, Florida

VERY GENEROUS

Dale Adrion, Thousand Oaks, California

Susan and Jim Brickman, Dallas, Texas

Lisa and George Foreman, Watkinsville, Georgia

Gary Key and Edwin Hackney, Lexington, Kentucky

Morris Book Shop, Lexington, Kentucky

Carroll Muffett and Tricia Davis-Muffett, Washington, D.C.

Bill Payne, Frankfort, Kentucky

Rick and Sallie Showalter, Georgetown, Kentucky

Kathy and Tom Stanwix-Hay, Lexington, Kentucky

John Trutko and Debbie Neeley, Arlington, Virginia

BEYOND GENEROUS

Linda and Curtis Green, Lexington, Kentucky

Aaron Lee Lawrence, Eastham, Massachusetts

Todd Lowe, Louisville, Kentucky

Dennis Ogden, Boca Raton, Florida

Arturo Alonzo Sandoval, Lexington, Kentucky

Lana and Gene Turner, Pelham, Alabama

COLOPHON

Gotham
Gotham Narrow
Adobe Caslon Pro
Bickham Script Pro Regular

CAMERA NOTES

Photographs made between January 10, 2004 and April 28, 2006 were taken with an Olympus C3100Z.

Photographs made between May 16, 2006 and November 12, 2010 were taken with a Canon PowerShot S2IS.

Photographs made between January 4, 2012 and November 10, 2013 were taken with a Canon EOS 60D.

ZEDZ® press

The Zedz Press mission is to publish books and printed materials about regional culture, art and photography.
Kentucky 120 is the first book published with the Zedz Press mark.
Join the Kentucky 120 blog at www.zedzpress.com.